Julian Bell is a painter and writer who teaches at the Royal Drawing School, London. He is a contributor to the *Times Literary Supplement*, *Modern Painters*, the *London Review of Books* and the *New York Review of Books*, and his books include *What is Painting? Representation and Modern Art* (1999 and 2017), *Mirror of the World: A New History of Art* (2007) and *Natural Light: The Art of Adam Elsheimer and the Dawn of Modern Science* (2023), all published by Thames & Hudson. He followed his father, Quentin Bell, in working as an artist and writer; his grandmother was the painter Vanessa Bell. He lives and works in Lewes, East Sussex.

POCKET PERSPECTIVES

Surprising, questioning, challenging, enriching: the Pocket Perspectives series presents timeless works by writers and thinkers who have shaped the conversation across the arts, visual culture and history. Celebrating the undiminished vitality of their ideas today, these covetable and collectable books embody the best of Thames & Hudson.

JULIAN BELL
ON PAINTING

With 26 illustrations

This book consists of extracts from *What is Painting?*
by Julian Bell, originally published by Thames & Hudson
in 1999 and released in an updated edition in 2017

Front cover and endpapers: Georgiana Houghton,
The Omnipresence of the Lord (details), 31 October 1864.
Watercolour and gouache on paper, 23 × 32 cm (9⅛ × 12⅝ in.).
Collection Victorian Spiritualists' Union, Melbourne

Published in the United Kingdom in 2017 in
What is Painting? by Thames & Hudson Ltd,
181A High Holborn, London WC1V 7QX

Published in the United States of America
in 2017 in W*hat is Painting?* by Thames & Hudson Inc.,
500 Fifth Avenue, New York, New York 10110

This abridged edition published in the United Kingdom
in 2024 by Thames & Hudson Ltd, 181A High Holborn,
London WC1V 7QX

This abridged edition published in the United States
of America in 2024 by Thames & Hudson Inc.,
500 Fifth Avenue, New York, New York 10110

Julian Bell on Painting
© 2024 Thames & Hudson Ltd, London
Text © 2017 and 2024 Julian Bell

British Library Cataloguing-in-Publication Data
A catalogue record for this book is available from
the British Library

Library of Congress Control Number 2023952404

ISBN 978-0-500-02728-8

Printed in China by Shenzhen Reliance Printing Co. Ltd

MIX
Paper from
responsible sources
FSC® C102842
www.fsc.org

CONTENTS

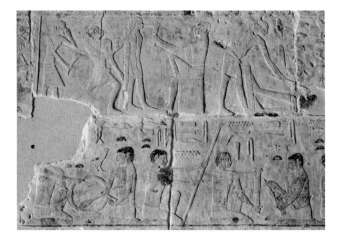

1. Detail of a relief from the tomb of Ankhmahor, Saqqara, showing Egyptian sculptors working on two statues, Sixth Dynasty, c. 2345–2181 BCE.

ORIGINAL AND IMAGE

> Thou shalt not make unto thee any graven image,
> or any likeness of any thing that is in heaven above,
> or that is in the earth beneath, or that is in the water
> under the earth: thou shalt not bow down thyself
> to them, nor serve them.

Why? What makes the God of the Bible forbid all likenesses in the Second Commandment, before pronouncing on killing, adultery and theft?

Images draw us in. The desire to make and attend to likenesses has been powerful throughout history. Their presence in human society has been the rule, and their absence the exception, during the last six thousand years. The Ten Commandments, however, set a control on this desire to make likenesses; but even a people bound to Moses' law, as the Old Testament relates, needs to be repeatedly restrained from making and contemplating 'idols'.

How man-made images have been understood in history is the concern of this book. In particular, it examines the images called paintings, and specifically the history of the last two hundred years, during which painting seemed to part company with the age-old desire for likenesses. But this development of modern art needs to

be understood within much larger traditions. A contest of feelings about images stretching back to ancient Israel and Greece underlies the complex values we now give to that word 'painting'.

A Jewish text from the 1st century BCE, the Wisdom of Solomon, dwells on idolatry with scornful amazement. A carpenter takes an offcut of wood and 'by the skill of his understanding, fashions it to the likeness of a man'; then, fastening it to the wall to stop it falling, 'for it is an image, and hath need of help', he 'for life, prayeth to that which is dead'. Do not be deceived, the writer adds, by 'an image spotted with divers colours, the painter's fruitless labour'.

The writer of these words was very likely casting aspersions on the visual culture which dominated his era and which still influences ours: that of ancient Greece. Greek accounts of image-making and its origins are at first sight quite different. The legend given by Pliny, for instance, is sweetly romantic. A maid of Corinth was bidding farewell to her lover, who was about to cross the sea; noticing his shadow cast on the wall by a candle, she seized a stick of charcoal from the fire and traced its outline. The scene was often depicted by late-18th-century painters, no doubt influenced by the contemporary fashion for silhouettes.

The impulse of the Corinthian maid, in the legend, was enough to initiate likeness-making. Yet that impulse was prompted by an imminent absence, the departure of her lover. For her, the tracing was evidently a second-best, a substitute: 'Only a picture', as we say. In fact, for all their

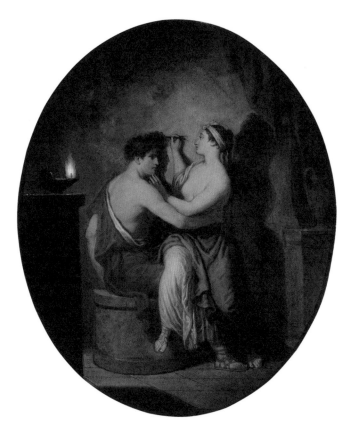

2. David Allan, *The Origin of Painting*
('The Maid of Corinth'), 1775. Oil on panel.

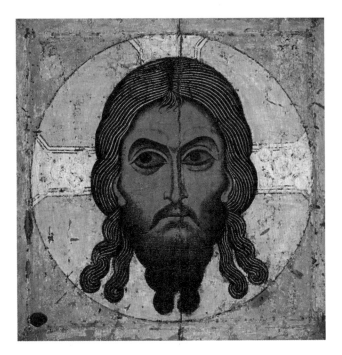

3. *The Vernicle*, a Russian two-sided icon,
12th century. Tempera on wood.

dissimilarity, the Greek storytellers and the Hebrew prophets share several common premises about man-made images. They take it that an image is not the original thing, but is – or ought to be seen as – a substitute for it; and that, nevertheless, it has a fascination in its own right, a power to command the eyes. In sum, they believe that the image is initially made as a channel for human desires, but that it subsequently diverts them.

These intuitions about images spread very wide in human culture. Turning to the image to answer our wishes, we take it to have a dependent, secondary relation to the original that is its cause. If we rely on it to satisfy our demands, this is often because we believe that it is itself reliably attached to the object for which it is a substitute. This attachment may have a physical status: the camera's mechanical record of transmitted light is a guarantee of this sort. But even if such a material attachment is lacking, we may uphold the status of the image by a principle of spiritual attachment. For instance, we may say that the likeness of someone holy or divine has been directly imprinted on the working material by an inspiration from above, with the human maker merely functioning as a tool. Thus in the Orthodox Church, icons of the Saviour were produced with minimum deviation century after century because they were intended to be *acheiropoietai*, 'things made without hands'. The lack of individualized intervention made them transparent receptacles for their divine content.

Yet this appeal to divine inspiration was used to defend images against the contrary intuition: that they

may deflect our attention from what they represent. The visible substitute may gain favour at the expense of the absent, invisible person or entity it stands for. Between the original and the viewer the seductive power of image-making intervenes, a force that may be seen as magic and malign. This suspicion was voiced not only in the Jewish tradition but also, with an added twist, in the early 4th century BCE, by Plato in *The Republic*. Painters, Plato accuses, distract our attention with their likenesses of the way things look; yet the way things look is itself only a poor likeness of their true nature. For truth belongs with the idea: the permanent, God-given form behind each appearance we perceive. Copying mere appearances, the painter 'knows nothing worth mentioning about the subjects he represents', and we can conclude, Plato writes dismissively, that 'art is a form of play, not to be taken seriously'.

In this attack on image-making, Plato – following his mentor Socrates – characterized the practice as *mimesis*, a noun formation from the verb *mimeisthai*, meaning 'to mime', a bodily performance in which you tell a story, or bring someone's presence to mind, without speaking. The insistent, attention-seeking aping of appearances that invited Plato's scorn may perhaps be seen in the few fragments of sophisticated fresco painting to have survived from his day, such as the tomb mural discovered at Vergina in northern Greece. We might call it 'painterly flair', but in terms of Plato's theocentric approach, it was triviality on triviality, at a double remove from the truth. Mimesis, however, was to become the principle

that would underpin the intellectual status of Western painting for centuries.

The development is due to Aristotle, writing a generation after Plato. Rather than attempting to transcend the visible world, the younger philosopher was concerned with giving a coherent account of it, and he saw mimesis as a vital tool in doing so. He used the term to describe something that happens throughout painting, sculpture, poetry and drama, and also in some forms of music. Through these means, wrote Aristotle, people enact the likenesses of other persons or phenomena – that is, they 'put themselves into them', as it were – as a way of comprehending them. 'It is through mimesis that man develops his earliest understanding.' Children, then, with their make-believe and toys – their 'early learning aids', as we now say – were included in Aristotle's psychology. All such activities, from his point of view, offered a sane way of widening the mind's access to the world, with the potential to cleanse the emotions rather than to tantalize and warp them. Play might be an alternative to work, yet play still had a purpose.

This acceptance of images by Aristotle on the one hand, and the Platonic and Judaic rejection of them on the other, hinge on an ancient and well-trodden opposition of terms: knowledge versus feeling, logic versus intuition, head versus heart. Aristotle inclines to see images as coming from one side of the opposition: people make them because of their wish for knowledge. Plato suspects them of coming from the other: people make them to indulge their desires – vain desires, from his point of view.

The battle between these two viewpoints has not gone away. Among Christian societies, proponents of Plato's suspicion have included the original 'iconoclasts', who banished images from churches in the Byzantine Empire during the 8th century, and the Puritans who smashed up much of Britain's artistic past during the 16th and 17th centuries. In their wake, comparable destructions of art were carried out by secularizers during the French Revolution and China's 1960s 'Cultural Revolution'. Meanwhile Muslims, from the time of the Prophet onwards, have followed Jews in being wary of figural imagery, and most recently it has been Islamist movements which have courted attention by carrying out spectacular acts of iconoclastic violence. There is an understandable impulse to call their perpetrators 'barbarians', but the supposed point of principle behind such actions – that images are made to cater to human desires, and that they can divert them – is one that any form of civilization has to acknowledge, for instance via its policies towards pornography. As long as images continue to have force, so do objections to them.

PAINTINGS AND PAINTING (AND PHOTOGRAPHS)

Let me establish what I mean by painting; since it is painting, rather than 'images' or 'the arts' in general, that I hope to explain. Arguments about 'images' may extend equally to work in either two or three dimensions, and as much to mechanically produced likenesses as to handmade objects. 'The arts' are a category we owe ultimately to Aristotle, who sought to account not only for painting but also for sculpture, drama and poetry with his doctrines of mimesis. 'Painting' may well fall within these two broader categories, but it also forms its own distinct category, and does so in two ways.

There are *paintings*. People across the world have fixed pigments to all kinds of surfaces – walls, hoardings, panels, canvases, pavements, box lids and so on – aiming to do something more than hide or protect the raw material beneath. When we call the results 'a painting', we mean that a set of the resulting marks comes together to claim our attention. Calling it by that name, we think of it as a particular type of human product.

And there is *painting*. This is the activity that unites these objects, one that makes us think of them as demonstrations of a certain 'art', rather than as surfaces that

merely happen to have paint on them. Painting is the manner of production that distinguishes these flat things from other sorts of marked surface – from writings, photographs and so on. If the objects are products, then painting – the concept that ties a set of visual experiences together – is a practice.

What does this practice, this unifying factor, consist of? We have seen that until the 18th century, at the least, it had one common, minimal definition in the West: painting was the marking of surfaces so as to represent visible things. To restate this still widely entertained idea: paintings present us with the sight of things we might see otherwise. In particular, they use two dimensions to show us objects we might potentially see in three. What we see on the flat corresponds on a basic level to what we might see in the round. To take an example of the practice at its most vigorously direct: the painting by Hermenegildo Bustos, a self-taught 19th-century Mexican artist, offers you the sight of fruit, the like of which you might pick up and eat. Producing this experience of 'pictorial representation', so the idea goes, is the distinctive business of 'the art of painting', separating it from 'painting and decorating', the application of paint to cover and adorn surfaces.

This definition of painting, which effectively restates the theory of the imitation of nature, no longer looks adequate. It has quite evidently been insufficient since the advent of abstract painting around 1910, but it had already been superseded in the eyes of many painters since the later 18th century. But to get the full measure

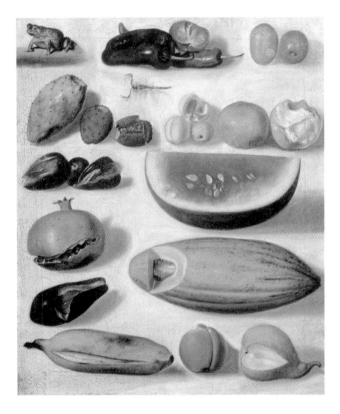

4. Hermenegildo Bustos, *Still Life with Fruits, Scorpion and Frog (Bodegón con Frutas, Alacrán y Rana)*, 1874. Oil on canvas.

of this change, or reformulation, of painters' practice we need to step back for a while from historical arguments and expand on our definition of the objects called paintings.

A painting is the flat thing formed by marks and a surface, I wrote above. 'Surface' seems reasonably unambiguous. Any visible, solid expanse which stops the passage of light could be used as a 'ground' on which painters could do their painting; but once it is marked, the surface of the ground will become an integral part of that painting.

'Flat' seems clear enough, too, since it seems to be only the surface that really concerns the painter. It might, it is true, be more accurate to say 'flattish', if we consider the way paints can cake up and the complex signals our eyes may have to interpret about the under- and over-layers of pigment that the painter has applied. Nonetheless we habitually scan the results of that work as a more or less two-dimensional spread.

The word 'marks', however, requires more explanation. Marks are made not only by brushes, pencils and similar graphic (that is, 'marking') tools, but also by tyres skidding, boot studs on a pitch, pebbles scuffing one another as the tide rolls them and so on. A mark is whatever we see that we recognize as having a cause – whether that cause is intentional or not. We see it and we see past it, or into it; it is what it is and a reminder of something besides. It is when we see something in that double, ambivalent manner that we call it a mark.

As such, a mark is a sign you can see. A sign, in logic, is something which points beyond itself; something

which means. Obviously, the prime example of a sign you cannot see is the spoken word. Semiotics – the study of signs, which greatly influenced theories of art of the later 20th century – compares and sorts words, marks and whatever else has significance. From its point of view, the relationship between the thing itself – the sound, the brushstroke or the scuff on the pebble – and the thing it points the mind towards is one of 'denotation', or, quite simply, 'representation'.

But – and this is one of the concerns of the semiotician – paintings seem able to attach themselves more strongly to what they represent than words can. The picture, in this sense, was traditionally defined as a *natural* representation – one that works by presenting again what nature presented first. We come down to the distinction between what comes from God and what comes merely from humans. And this leads to a certain paradox: the same impulse that leads the Jewish tradition to favour the divinely created wild flower above the humanly fashioned painting directed Greek philosophers to grant precedence to the painting, which is representation using 'natural' means, over the spoken word, which is representation by human convention. Thus the wordsmith Plato, for all his scorn of painting, composes a hymn of envy to the art in the dialogue *Cratylus*, in which he tries through far-fetched etymologies to give words the same stable status of transmitted natural fact that pictures seem to have: as if all speech and writing were like the letter 'O', which pictures the shape of the mouth that pronounces it.

The classic account of excellence in painting is the Greek story of the two rivals Zeuxis and Parrhasios. Zeuxis painted grapes so lifelike that the birds tried to peck at them; but when he wished to inspect Parrhasios' showpiece he himself was fooled – the curtain he tried to pluck turned out to be the painting. By this standard, trompe l'oeil, in which human work most closely replicates nature's work, is the definitive mode of painting.

This was an ethos enthusiastically adopted by the Romans, as can be seen in surviving murals from their villas. While illusionistic painting was marginalized for a thousand years after the rise of Christianity, it was reanimated at the turn of the 14th century by Giotto – as much in the eye-teasers he appended to the Arena Chapel in Padua as in the solidly embodied figures of his stories. With these, Giotto established the idea that a painting could be like a window – an idea that would be given systematic form when Filippo Brunelleschi developed the technique of 'artificial perspective' around the year 1423. 'Natural perspective' consists of the geometric rules that define how light comes to the eye; Brunelleschi showed how these rules could also be used to define what can be shown in a painting, and the way things appear in it in relation to the angle of vision (their 'aspects').

Even more important than the practical usefulness of the techniques of perspective – which painters generally used at their discretion, rather than as fixed rules to be obeyed – was the intellectual status they lent to painting. According to Leon Battista Alberti and Leonardo da Vinci, the major Renaissance theorists, this apparent window

5. Giotto, *An illusionistic window* (detail),
Arena Chapel (also known as Scrovegni Chapel),
Padua, 1303–5. Fresco.

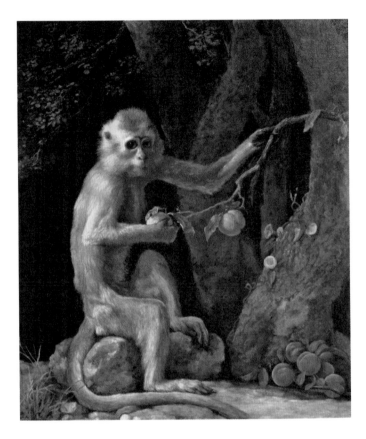

6. George Stubbs, *Portrait of a Monkey*, 1774.
Oil on panel.

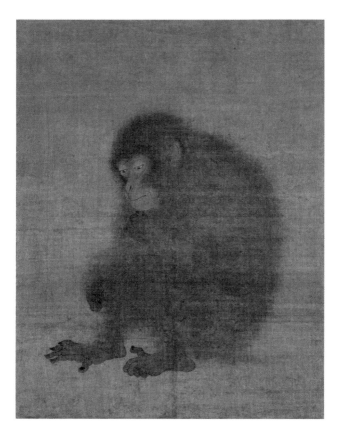

7. Attributed to Mao Song, *Monkey*,
13th century. Ink, colour and gold on silk.

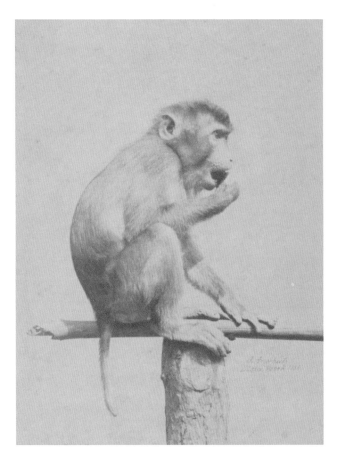

8. Ottomar Anschütz, *Monkey*, *c*. 1886.
Albumen print.

could open out on to the whole of nature: painting had the potential to offer a complete representation of the cosmos in all its diversity. Analysing and reconstituting all visible phenomena, painting became, for Leonardo, a primary demonstration of humanity's intellectual dignity. This was an argument that greatly empowered the painter. Vindicated by Leonardo's own investigations, it also applies to a line of artists before and after him: Van Eyck, Bosch, Michelangelo, Raphael, Dürer, Titian, Bruegel. Each of these Renaissance originals clearly extended the range of what might be represented in paintings. And yet to invoke such a range of European artistic identities is to recognize that representation per se cannot be some simple, unitary endpoint of painting. And the problem only expands if we look further afield.

Consider two paintings of monkeys: one painted in 13th-century China, and one in 18th-century England. Everyone can agree that Mao Song and George Stubbs had both looked long and hard at these animals and were confidently in command of their respective crafts. Would anyone care to say, however, whether one painting or the other should have priority as a representation of a macaque? If we choose the spare, suggestive concision of Mao's pen and brush, we miss a certain sharp truth that Stubbs is able to dramatize: that the monkey knows that humans are looking at it and that picturing it, we have a kind of power over it. If we opt for the Englishman's highly modelled, anatomical analysis, we don't attain to the more contemplative truth that Mao is able to dwell on: that there is something it will always feel like for the

monkey to be a monkey, that there is an inner quality and a depth to its life.

Each representation is necessarily partial. Accepting this and appreciating both, we may accept that every representation is grounded in a certain *style*. Style at once enables and sets limits to the imitation of nature. The style traditions of China and of Europe, each of them complex and supple, have enabled and set limits in differing ways.

Or do we wholly accept this? Don't we tend to think that style is a human limitation typical of handmade products such as paintings, but that this limitation can be progressively overcome the more we entrust the task of picturing to neutral machines? At each incoming stage of image technology – the photograph, the holograph, the computer simulation – there is the expectation that the representation will be more full of the subject itself and less tinged by the observer's presuppositions: ultimately, style-free. Then looking back, we realize that, say, an 1880s albumen print of one of Ottomar Anschütz's photos of monkeys remains interesting largely because it reveals a period style of its own – as, in due course, will the CGI monkeys of the 2010s.

The more we focus on style, the less we hanker after a 'perfect' imitation. We start to think that representation in images depends on social convention, much as representation in words does: a conclusion perhaps first reached by the philosopher Thomas Hobbes in his 1651 *Leviathan*. Hobbes notes that likeness is not indispensable, for 'a stone unhewn hath been set up for Neptune.' Such a representation is 'arbitrary' – arbitrary in the

17th-century sense of submitting to arbiters and settling matters under a common rule.

One monkey, then, gets represented according to a certain agreed relationship between images and things in China, and another under an alternative arbitration in Europe. This type of approach had become inbuilt into the discipline of art history by the 20th century. It sidelines the question of how, sight for sight, the depiction may resemble the object depicted. It stresses instead the principle of consent, through which the one is agreed to stand for the other as its substitute. Representation, from the point of view of the art historian, was no longer seen as imitation: it was substitution.

EXPRESSION

'Expression' has come to replace 'pictorial representation' (or 'the imitation of nature') as the most respectable job description for painting. To take a standard reference point: after explaining that it usually involves pigments and brushes, the 2016 Wikipedia entry on 'Painting' goes on to define the practice as 'a form of creative expression'. Once, painting was referred first of all to something out there, to nature. Now it gets referred to something inside: for the present definition would be incoherent if painters had nothing within themselves to express.

It seems that much of painting as we now know it depends on this premise. I should like to track some of the changes in thinking that have brought about this situation and that have taken us away from the former definition of painting. Thinking about expression will also involve asking broader questions: not least, what we mean when we talk of a 'person'.

Persons are implicated in all talk about expression because the term itself is a physical metaphor for a mental process which belongs to individuals. There's something inside wanting to show itself, there's a medium or environment outside waiting to receive it, and *a* gets ex-pressed – literally, in Latin, pushed or stamped out – into or onto

b. That seems to be the notion uniting the meanings that cluster around the term. In effect, expression is not so much an alternative to the processes of representation, as a way of approaching them in terms of muscular effort. It implies that there is an energy forcibly pushing forth whatever we have within us, so as to turn it into physical sounds or sights.

We experience this process as an effort because there is an inward resistance, against which we must heave. This resistance, to see it one way, is our own stupidity; we want to say something but cannot find the words; we want to depict something but draw the wrong line, and have to correct it again and again. We are not like the printing machine that stamps out exactly what is put in, transmitting it 'express' (i.e. with nothing intervening between order and delivery); we have a certain inner grain that transmutes all our *im*-pressions before they emerge into outward form. To see it another way, this inner transmutation is a grace within us: expression can be what a performer adds to a musical score, turning a neutral notation into an emotional experience for others.

This experience of resistance and change is one of the things that tells me there is an inside to me – a mind. The fact that other people report or picture things differently, as they transmute them, is one of the reasons that I assume they have minds also. Mindlessness, we believe, is a property of printing machines, with their faithful transmission of impressions. (Until, that is, the machine refuses to obey us, revealing an evil 'mind of its own'.) Resistance and change are both sorts of pain.

The fact that I experience pain that you say you do not feel tells me that there is an internal, limited thing that constitutes 'me'. The limited extent of the pain defines me as a person, whether that pain is mental – the difficulty of expressing things correctly – or physical. (One bodily analogue for expression, in fact, is excretion: a thought not lost on Piero Manzoni, who in the 1960s canned, labelled and sold several tins of *Artist's Shit*.)

One obvious candidate to carry the burden of expression in painting, it seems to us now, is colour. Colour is what we irresistibly associate with feeling: metaphors about 'red anger', 'the blues' and so on leap from eyesight to speech and back again, and linkages of this kind have probably always been evoked by painters. But could there be ways to coordinate these points of connection, so as to deliver a way of painting that becomes systematically expressive?

It depends on what paintings relate to. Approach them as representations of the world, and you might expect them to be constructed in the way that the world is constructed. The world, according to philosophers and scientists from Plato onwards, is first of all form. Forms – ideas – precede colour, which is a 'secondary quality', an icing on the cake. Paintings proceeded correspondingly. Lines were drawn, defining the forms, and then colouring was added.

As a result, issues of colour were less subject to systematization than issues of form, supervised as these were by the disciplines of perspective and anatomy. Dealing with pigments daily, painters worked out various rules

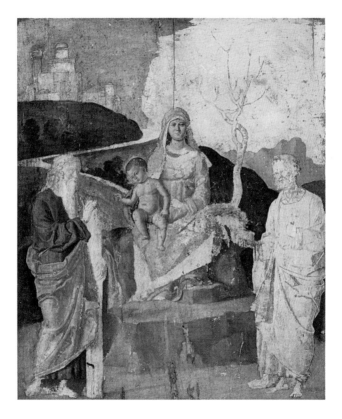

9. Workshop of Giovanni Battista Cima da Conegliano, *The Virgin Mary and Child with Saint Andrew and Saint Peter* (unfinished), late 15th–early 16th century. Oil on panel.

of thumb and applied these to the schemes of meaning assigned for their work. To honour the Virgin Mary, her robe would be rendered in costly lapis lazuli, but for the blues of a landscape shown behind her, the cheaper pigment called smalt might suffice. Codes of symbolism, economic considerations and job-specific techniques (the usefulness for instance of terre verte, 'green earth', for the underpainting of flesh tones) overlapped to provide painters with a know-how, a lore.

If, however, you think of paintings as expressing the painter – the shift we have been discussing – then how shall they be constructed? The painter is an individual who relies on his eyes, and when it comes to eyesight, colour is primary. 'We see nothing but flat colours,' Ruskin pronounced in 1857. 'The perception of solid Form is entirely a matter of experience' – an analysis to follow on from the initial 'childish perception of those flat stains of colour', one from which we eventually derive a workable understanding of the outside world in general. Ruskin was articulating an approach to colour that might be traced back to Isaac Newton's experiments with the prism, published in his *Opticks* of 1707. For the first time Newton showed how colour could be conceived as a cohesive range – a 'spectrum' – of variations in light.

The notion of a spectrum of colours reinforced an analogy between arts that writers had already liked to entertain, because this encompassing range of possibilities seems not unlike a musical scale of notes. The comparison became a distinct programme from the 19th century onwards.

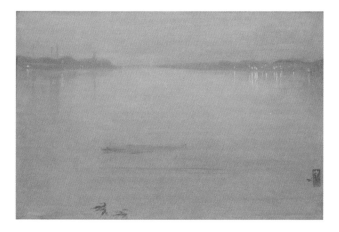

10. James Abbott McNeill Whistler, *Nocturne: Blue and Silver – Cremorne Lights*, 1872. Oil on canvas.

Baudelaire in his Salon of 1846 rhapsodized about the 'great symphony' – the 'succession of melodies', the 'complex hymn' – which 'is called colour'. The familiar tropes he played with – colour 'harmonies', and so on – were starting to impinge on studio practice. If only painting could be pure feeling, in the way that Beethoven had shown that music could be! If only it did not have all these subjects and references hanging round its ankles! In this spirit, Whistler chose to entitle his 1860s portraits 'symphonies' and his 1870s townscapes 'nocturnes'. Here we start to see how the objective of expression might end up at cross-purposes with that of pictorial representation.

If the later-19th-century picture market had room for Whistler and his musical pretensions, this was because the hold of fixed categories such as 'the portrait' had slackened – as had the authority of academies that ranked these hierarchically. Metropolitan clienteles jumped genres in their search for sophistication, and landscapes might bear as much value as history paintings. From 1841, painters catering to their tastes could buy colours in metal paint tubes that were more transportable than any previous form of container. A direct response in colour to scenes observed outdoors became a viable option, as never before. 'Without tubes of paint, there would have been no Impressionism,' Renoir once claimed. After some initial resistance during the 1870s, the market also took to this new picturing that revolved around landscape rather than around figures, and that negated line in favour of a flux of colour stimuli.

In the following decade, Van Gogh – Renoir and Monet's junior – came to Impressionism after a zealous self-education in line drawing. Rather than treating colour as primary sensation, he investigated, just as zealously, the way it could charge pictures with emotional content. 'Instead of trying to reproduce exactly what I have before my eyes,' he wrote in 1888, 'I use colour more arbitrarily so as to express myself more forcibly.' He stripped down his linear structures and loaded them with paint from the tube. 'It's simply my bedroom,' he wrote later the same year, 'but the colour has to do the job here.... Looking at the painting should rest the mind, or rather, the imagination.'

This simplification had been half foretold by Ruskin when he wrote that painters must recover 'the *innocence of the eye*'. 'How do you see those trees? They are yellow. So put in yellow.' This was Van Gogh's friend Gauguin, instructing the younger Paul Sérusier on how to interpret nature at just the same time as Van Gogh was painting *The Bedroom*. Many avant-gardists – not only Sérusier's friends the Nabis in 1890s Paris – took such precepts as their cue. Bold expanses of unmixed colour could speak truth about the painter's instinctual reactions while also steering the viewer towards some favoured state of mind.

Meanwhile other avant-gardists around the turn of the 20th century leant on optical science for their 'pointillist' (or 'divisionist') analyses of vision, dabbing the canvas with contrasting colours that would recombine with added vibrancy once viewed. Both approaches to colour converged exuberantly among the painters whose 1905 Paris exhibition got them labelled *les fauves,* 'the wild

beasts'. In fact Matisse, the central figure in this genera-
tion, was anything but wild in his thinking. His 1908 *Notes
of a Painter* declares that 'the chief function of colour
should be to serve expression as well as possible', but
makes it clear that the content to be expressed, within
this 'art of balance', must be stable and harmonious.
Chasing his intuitions about colour – boldly and joyously,
but also with a nervy vehemence – Matisse aimed to reach
beyond transient emotions: to arrive at a transpersonal,
by way of the personal.

To consider colour is to consider how you see things,
not what things you actually see. What would painters be
depicting in pictures that expressed the person painting
them? Yes, obviously, they might try looking in the mirror:
but self-portraiture, as normally defined, was less than
the challenge that the exponents of Romanticism had in
mind. 'The *world* must be romanticized,' the German poet
Novalis wrote. The world would be romanticized when
all its appearances had become personal feeling; when
objects had become subject, in the terminology of a further
theorist, Friedrich Schelling. For Schelling, this would
be achieved through art – through poetry and painting.

Romantic thought allowed that the 'subject' – the per-
son – might be a conduit for higher powers that employed
art to cut through external material appearances. In the
work of Blake, line becomes not a way of picking out and
discerning form from the outward world, but the track
of the active spirit, creating and evolving visibility out of
its own continuous movements. Matter is rejected: Blake
drew weightless figures, colouring them so as to let the

light of the paper shine through, disdaining the fattiness and opacity of oil paints.

This approach would be taken much further by another painter working in the same tradition – a tradition that was indeed scribbled in the margin of contemporary discourse, pursued in considerable cultural obscurity. For Georgiana Houghton, whose work was exhibited in London in 1871, the spirit that guided her drawing hand in spiralling convolutions was literally beyond her self, her own area of control; the results of this mediumistic vision were among the first paintings in the Western tradition that we would nowadays class as 'abstract', lacking any discernible reference to the outward features of the world.

Houghton's paintings were known, it would seem, at second or third hand to Vasily Kandinsky, the painter most often credited with inventing abstraction with his paintings from 1911 to 1914. He would have come across such images among the illustrations to the Spiritualist volumes that he was studying. A few other individuals – notably the writer Victor Hugo and the Swedish artist Hilma af Klint – had likewise already explored quasi-abstract imagery in the context of 19th-century Spiritualism.

In the 1880s Symbolism had become the vogue in Paris – a development that is one of Baudelaire's many legacies to the culture of painting. When Albert Aurier, a leading theorist of Symbolism, wrote that painting should set itself not towards 'the direct representation of objects...

Overleaf 11. Georgiana Houghton, *The Omnipresence of the Lord*, 31 October 1864. Watercolour and gouache on paper.

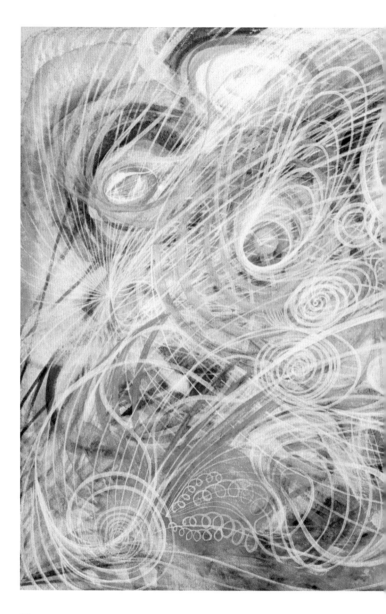

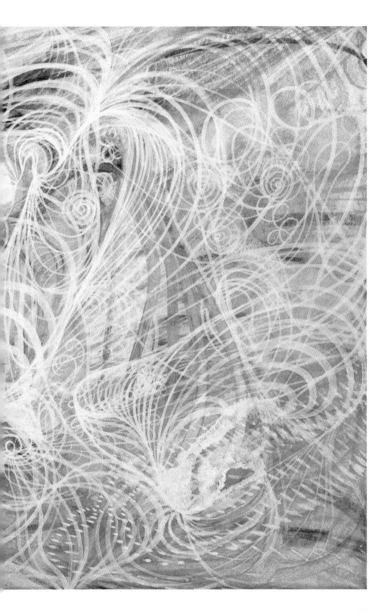

but to express ideas as it translates them into a special language', or when Odilon Redon spoke of painting as 'the logic of the visible at the service of the invisible', they were picking up a Romantic agenda transmitted by Baudelaire's criticism.

As Symbolist ideas got diffused during the 1890s and 1900s, their underlying premise that painting needed to be expressive, rather than imitative, increasingly settled in as a commonplace. Within the circle of acceptance thus created, avant-garde groups dedicated to the idea of progress saw that painting might need to be further redefined and to discard its previous remit of representing nature. The routes pursued by Kandinsky, Malevich and Mondrian, the three 'fathers' of abstract painting, all issue from this nexus of utopian thought. The route Kandinsky took led to a new formulation: colour itself was the intrinsically spiritual within the world, its *innere Klang* or divine resonance. Declaring colour by itself, without recourse to preordained imagery, the painter could open out and unfold the realm of the spiritual, helping to bring a new world into being. The imagery of unfolding and exploration was developed further by Kandinsky's friend and sparring partner Paul Klee, whose far-ranging investigations produced a comprehensive theory and a vast body of work demonstrating how painting could proceed from inward, organic principles.

All these progressive initiatives – the freeing of colour from form, the freeing of painting from imagery, the freeing of art from the frame – proceeded more or less organically out of what we might call the deep-mind

scenario, the prospect opened up by Romanticism. They pitted art against the unwelcome outcomes of the shallow-mind scenario – the dead, inorganic accretions of 'soul-less', exploitative science and industry, the 'long reign of materialism' that Kandinsky deplored. In the 20th century, a new art – one that might be able to make its peace with science, an art based on proven laws of colour – would transform all that.

But the logic used by artists to rebut the capitalist consensus switched after the catastrophic disillusioning of World War One. Romantics and Symbolists had felt that in the mind's furthest reaches the divine stands revealed. Freud's psychology, developed from the 1890s onwards, insisted instead that the mind is at root an adjunct to a needy, material body. The art movement that seized on this *aperçu*, Surrealism, used mind to denounce mind, much as one of its leading exponents, Joan Miró, claimed to be using painting in order to 'kill painting'. Surrealism assaulted the tactile boundaries of the self, promoting instead the visceral, the pre-verbal and the instinctual. At the same time, insofar as it co-opted painters who needed sales, it necessarily remained another marketable form of 'self-expression'.

For in talking about ways of defining what a person might be, we are inevitably talking about personas – the fronts behind which painters present themselves to those who might be prepared to keep them in business. Even the most earnest and hard-fought-for artistic radicalism has to engage at least a few viewers, in order that the painter may continue to produce. Surrealist circles buzzed with

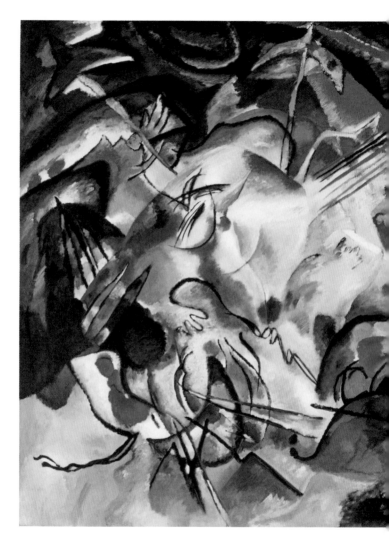

12. Vasily Kandinsky, *Composition VI*, 1913.
Oil on canvas.

radical yearnings, voicing their hopes to leave behind all familiar conceptions of art. But the interwar period in which they flourished was brief and politically hemmed in. By the early 1940s, with the Nazis in control of Europe, the most that most artists there could hope for was merely to withhold despair. For those who emerged in mid-decade from the traumas of occupation and massacre, what style of persona remained viable?

They could find a certain marker for attitude in Picasso's prewar production, above all the 1937 *Guernica*. That conjunction of contemporary news and timeless myth, of outward politics and inward psychology saw Picasso – who had spent time with the Surrealists – likewise giving himself over to his id and committing his body-fixated art to his own lusts, rages, dreams and nightmares. For the postwar generation, then, there was the prospect of plunging their arms into deep, dark dirt – not only psychic dirt, but emphatically physical gunk – clotted impastos, matière in the studio jargon of the 1940s and 1950s. And yet their heads would be raised to look the world in the eye, gravely and defiantly. They would be bearers of witness – perhaps politically, perhaps existentially, insofar as the existentialism of Sartre and Camus was the era's favoured creed. Let the artist's gesture constitute the declaration 'I exist' in the face of tragic cosmic indifference.

One vivid presentation of this persona came from Francis Bacon, Picasso's British devotee, who launched his career in 1945 with his *Three Studies for the Base of a Crucifixion*, monstrous figures serving as harbingers

of contemporary crisis. Other prominent exhibitors in post-war Europe, ranging from Alberto Giacometti and Jean Dubuffet to Alberto Burri, also put forward bodies that were challenged or ravaged – in Burri's case, via a wounded and sutured flesh of ripped and stitched sacking. But the emergent mid-century ethos cuts across the abstract–representational divide, and across the Atlantic. The New York painters who absorbed and moved on from the influence of Picasso and the Surrealists – Jackson Pollock, Willem de Kooning, Mark Rothko, Franz Kline et al., the group known from 1946 as Abstract Expressionists – trusted in dramas of bodily confrontation. The artist's more-than-life-size gestures, overawing and engulfing the viewer, proclaimed his heroic engagement with that person's whole fabric. As Rothko put it, 'The reason for painting my large canvases is that I want to be very intimate and human.'

The word 'human' is significant here. On account of such usage, many writers since have identified the prevailing rhetoric of mid-20th-century art, in all its earnest, embattled physicality, as 'humanist'. 'Humanism' in this sense is not so much a creed contrasted to 'theism' (a common British and American opposition); rather, it concerns what the humanities, as opposed to the sciences, can supposedly supply – access to lived, felt, intimate experience. 'Science manipulates things and gives up living in them,' wrote Sartre's colleague Maurice Merleau-Ponty, a philosopher who found fresh ways to define the role of the painter in his writings at the turn of the 1960s. Merleau-Ponty contrasted science with painting, which 'draws

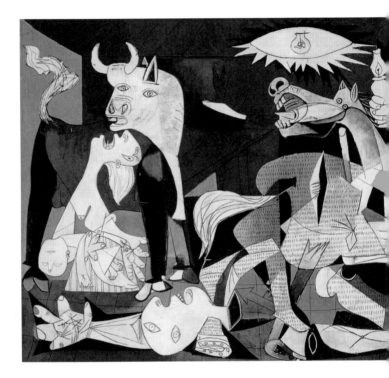

13. Pablo Picasso, *Guernica*, 1 May–4 June 1937.
Oil on canvas.

on the fabric of brute meaning which operationalism [i.e. purpose-oriented science and technology] prefers to ignore'. If the meaning is 'brute', that is because Merleau-Ponty's painter is above all a physical, material entity: 'It is by lending his body to the world that the artist changes the world into paintings.... Visible and mobile, my body is a thing among things; it is one of them. But because it moves itself and sees, it holds things in a circle around itself.' And thus the painting is the physical outcome of an interaction of internal and external physicalities: ultimately, all is body.

The label 'humanist' has been affixed to painting from the mid-20th-century in order to characterize it in contrast to opposing subsequent trends. And these succeeding art-world phenomena have been characterized not only as 'anti-humanist', but as 'anti-expressionist'. Jasper Johns with his laconically nullified everyday symbols such as numbers or flags; the foregrounding of mass-produced material by Pop artists in the 1960s; the deliberate avoidance of physical handicraft by 1960s 'Minimalists' such as Robert Morris and Donald Judd (even if the former happened to be playing with ideas raised by Merleau-Ponty) – all these were meant as breaks with expressionism in general. Most particularly, with the Abstract Expressionists, a generation deemed self-indulgently melodramatic by its juniors.

This stand-off then got replayed in the 1980s, when an international cohort of 'Neo-expressionists' – which ranged from Europeans such as Anselm Kiefer and Sandro Chia to American apostles of 'bad' painting such as Julian

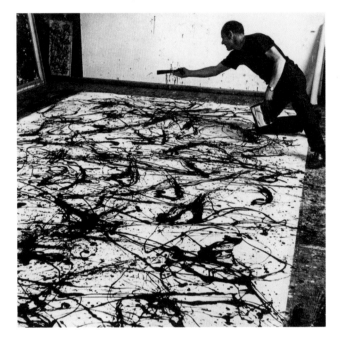

14. Rudy Burckhardt, *Jackson Pollock Painting
No. 32*, 1950.

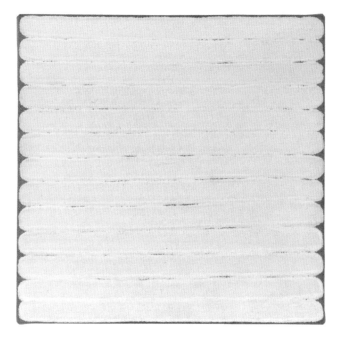

15. Robert Ryman, *Untitled*, 1965. Oil on linen.

Schnabel – swung into view with claims to reanimate the languages of oil paint and of myth; only for this loud version of postmodernism to be faced down by wised-up, cooler-headed operators such as Jeff Koons, the 'Neo-geo' artists including Peter Halley, and Koons's disciples in London, the so-called 'YBAs' or young British artists.

Non-expressive works – exhibits that do not point back to the individual who produced them – undoubtedly are possible. While I am obliged to mention names in order to talk about a Blinky Palermo 'fabric painting' or a Robert Ryman 'white painting', the works in question draw my attention to what the stuff of which they are composed is like. They quietly encourage contemplation. But this is to say that these more or less Minimalist pieces have made rather little noise on the art scene, compared to the loudly coloured, workshop-manufactured canvases of Warhol or Koons. And it is not primarily for the sake of their searing lemons and magentas that the latter items have commanded high prices. It is for the names.

For anti-expressionism is another persona, yet another mode in which the artwork expresses the artist and hence acquires value. This principle – an idea developed from the Romantic era through values such as authenticity, spirituality or sublimity and, more recently, through appeals to the corporeality of persons – has had incalculable effects on the development of painting in the last two centuries. No doubt most pictures in circulation continue to get valued for what they pictorially represent – that is why most photographs are taken. But it is probably true that most *paintings* are valued as personal

expressions – they are priced by the signature, even by people who care nothing for the ideals of expression I have been discussing. We tend to think that that is the value of paintings, as opposed to photographs.

Personal expression has, in effect, opened up the world of painting we see today: its whole repertory of colours, textures and forms has grown up through that ethos. It underpins the common intuition that if painting nowadays has a social function, it is to provide therapy and respite from fractured and distorting conditions for living. Focused on flat surfaces and on the pleasure of playing with pigments and markers, damaged persons may find some wholeness through creative expression.

They may. We all may. Within charmed circles of belief, urbanized painters may play out the unlikely role they have liked to claim for themselves after the modern rediscovery of palaeolithic cave art: that of the shaman, drawing on supernatural resources to heal the community. But let me put it brutally: expression is a joke.

Your painting expresses – for you. But it does not communicate to me.

You had something in mind, something you wanted to 'bring out'; but looking at what you have done, I have no certainty that I know what it was. Your colours do not say anything to me in particular; they are stuff to look at, but looking is not the same as catching meanings. Perhaps their array draws me in: I find myself, for instance, succumbing, like so many others, to awe before the paintings of Rothko. Perhaps your painting leaves me cold: so far, as it happens, it has only been by sheer willpower that

I have found anything to engage me in the brushwork of Giacometti. As for your impastos and sutures that struggle to be tactile, my experience of them is purely by proxy; if I try to repeat your hands-on experience of the paint, the gallery attendant will come running.

You – this is the point – cannot determine how I go about my looking. And hence painting, insofar as it is not mechanical transmission, is not communication. Insofar as painting involves the painter as an agent working with materials of complex composition, the specific meanings and intentions on which communication depends are deflected, turned into something other. And that something other – the actual residue of pigment – is indeterminate in meaning. It has 'meaning', insofar as we open our eyes to it and allow them to wander and gaze in fascination; but that 'meaning' is not an idea or an emotion, not a specific, unequivocal message. What we see is what we get: a product, not a process, lies on the wall.

But we are not happy to accept this. We yearn for expression to be communication, for every wandering mark to find its home. As a result, alongside this two-centuries-old growth of the painting of personal expression, a massive institution of explanation has grown up to control and stabilize the market. Part of it is dedicated to attaching a person to each picture – to weaving stories around the image, like the sentimental myths of 'the true artist' used as a fictional stock-in-trade and pick-up line the world over.

Another part offers to explain the principles that this art allegedly exists to demonstrate, ideas such as those I have just been outlining here. This wing of the 'Art'

institution may generate directives for taste which over-ride mere visual evidence, asking us to view products differently in the light of their producers' historical and biographical circumstances. Naturally, this book belongs within that sector of the institution. It has been written for anyone who has been intrigued into entering the institution's portals by those tantalizing, indeterminate markings called 'paintings'.

Yet the project in this case is to point a way through the institution's dim interior, towards the exit. To steer a path through the maze of words, towards the complex, but largely wordless pleasures of looking – that is the broad intention of this text. Because it is written by a painter, someone committed to producing objects specifically for viewing.

As a painter, however, it ill behoves me to treat the mismatch of expression and communication as a joke. It is a laughing matter, but there is a level on which all painters are clowns – the level on which people accept us. They indulge us in our self-indulgence, generously granting us credit for creativity even if the results are no more intelligible than the painting shown here: the untitled production of a psychiatric patient named Viktor Orth.

Yet this record of creativity, of human expressive vigour, retains a power to affect if we open our attention to its striving gestures. The swipes and splodges of colour thrill, seeming to promise 'meaning', though meaning no one thing. For viewer, as for painter, communication functions as a *hope*.

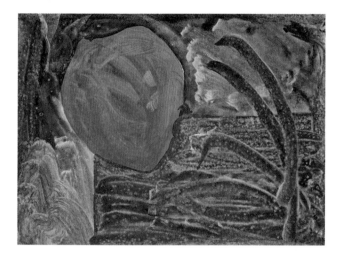

16. Clemens von Oertzen ('Viktor Orth'),
Untitled, no date. Watercolour on paper.

REPRESENTATION

'Representation' is the label we have commonly given to the age-old proposal about painting: that paintings are objects that show us, in two dimensions, objects we might potentially see in three. For a century and more, however, there have been objects which are undeniably paintings and which clearly don't do this. People therefore got used to talking about 'abstract' paintings as well as 'representational' paintings, and in the mid-20th century it was often felt that there was outright opposition between the two categories. But more recently, during the later 20th century, arguments arose that every sort of painting was in some sense a representation, and was to be sceptically held to account for that reason. This factored into a many-levelled conversation about the 'death of painting'. I should like to ask whether this conversation is itself now dead, before finally returning, after this tussle with words, to the speechless experience of looking.

Let me recapitulate some of the ways that the word 'representation' has been used by people who set out to discuss painting. These usages differ in scope and sometimes trip over one another.

(a) *Pictorial representation*. This is the idea mentioned above: the expectation that when you see this

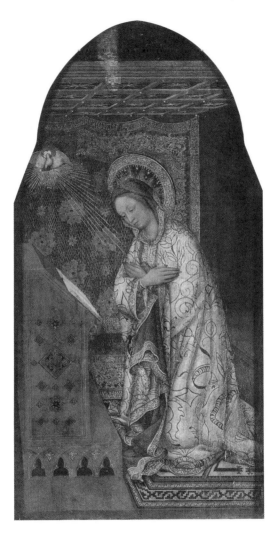

17. Jacopo Bellini, *The Annunciation* (detail of
the central panel), early 1430s. Tempera on panel.

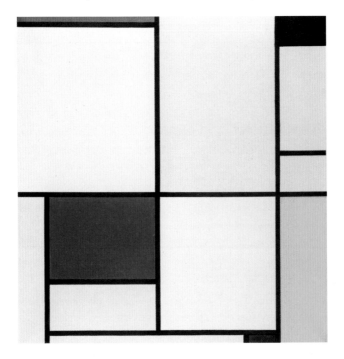

18. Piet Mondrian, *Tableau 1*, 1921. Oil on canvas.

picture, you will recognize that physical object. Since we tend to think of physical objects as defining what is real, this kind of representation is often termed 'realism'. It is this sense of representation that clashes with abstraction. When you look at a Mondrian, a Pollock or a Rothko, you cannot be reliably expected to think of any physical object other than the painting itself, whereas I should expect any person looking at the work above by Jacopo Bellini to recognize the types of object known as 'woman' and 'bird' within it – whatever else they might think of.

Abstractionists such as Mondrian produce paintings, but it might be said that they don't produce pictures: because the bid to get viewers to think of 3D objects, the bid that Bellini is making, is what we generally speak of if we use the word 'picture'. Pictorial representation, we tend to think, works when, and only when, the painting 'looks like' the object, at least to some degree; it is when the flat marked surface contains visual information that leads us to identify it with things external to itself. It is Plato's and Aristotle's *mimesis*, if you translate this as 'imitation' – that is, as making things like. It thus seems to be based on the possibility of resemblance.

(b) *Symbolic representation*. This is the idea I introduced when I spoke of pictures as a type of sign: the expectation that when you see this picture, you will think of that meaning. When you see this picture of a dove face to face with a woman, you will understand that the former means the Holy Spirit – if, that is, you share the painter's familiarity with this meaning, which is rooted in Christian doctrine. Symbolic representation, we tend to think,

works because, and only because, there is an agreement within a certain cultural system that one thing may be substituted for another.

But this statement needs refining, because symbols can work two ways.

Originally, Greek *symbola* were matching broken halves of a counter, used as pledges between people like ticket stubs. By extension, a symbol could be a likeness of a certain part of an original, taken for the whole of it. This relation is technically termed 'synecdoche'. A roadsign showing a worker with a shovel is a kind of synecdoche: it gives us just enough of a likeness of the snarl-up of hard hats, jackhammers and rubble occurring further on down the road to get us ready for the forthcoming delay. Likewise, Bellini shows us what is recognizably a woman seen from a certain angle, allowing us to think of the woman who is the Virgin Mary.

But this is not what is happening when Bellini makes a bird stand for the Holy Spirit. The Holy Spirit doesn't actually look like anything: it is by definition non-material. What is happening here is that one entire physical item is substituting for some other entire item, in this case something invisible but doctrinally crucial. Such a relation between two entire items constitutes a 'metaphor'. It is the *metaphorical* relation between items that we typically call 'symbolic'. A synecdochic representation is basically pictorial, being based on partial resemblance.

Symbols seem weaker than resemblances, insofar as they need a shared familiarity for their understanding. But symbols seem stronger than resemblances, insofar

as they enable us to communicate abstractions. Words are symbols – sounds substituted for physical objects – because, and only because, we agree on these meanings. But they are also substitutes for non-physical concepts: in common with other symbols, such as mathematical figures and coins, words may represent entirely abstract notions of number and value.

Painters in modern times may be concerned with abstract ideas and invisible quantities, just as the medieval painter was. But they are likely to be far less sure of communicating them.

(c) *Representation as system*. If symbols represent things because there is an acceptance within a cultural system that *this* may be substituted for *that*, then we might also use the word 'representation' to describe an overarching system that allows this to happen. Languages, numbers and currencies are systems of representation we are all familiar with. Each of them gives rise to items that are symbolically useful – words, decimal or binary figures, notes and coins. But there might be broader, deeper systems than these, giving rise to every sort of item that has meaning in human culture.

How could we identify such systems? Typically, we accept that *this* can stand for *that* because we find ourselves within a certain system or environment of meanings from the day we are born. And yet it is possible to contest such systems, at least in part. Theorists put forward overviews that purport to free us from them: notably Karl Marx with his class analysis of history, which describes systems of value that serve class interests as 'ideologies'.

The most widely read book of art theory of the later 20th century, John Berger's *Ways of Seeing*, presented an analysis of European painting tradition that leant on Marxism. Berger interpreted oil paint as a medium that sensually glamorized the textures of depicted objects and which therefore served an economic system pivoted on commodities and acquisition, in other words capitalism. An aspect that particularly resonated when Berger's book came out in 1972 was the relevance of his arguments to the then burgeoning feminist movement. Prime among the objects glamorized by oil paint, Berger argued, was the naked female body offered up for male delectation. The female nude, as epitomized in Titian's imagery, was a tradition that needed to be critiqued, arguably by work such as Alice Neel's .

An overview of a representational system could be used for a specific purpose such as this political critique, but it could offer more general intellectual liberation. The books that the philosopher Michel Foucault started bringing out in the 1960s made an impact on campuses for this reason. Foucault presented histories of changing regimes of thought in post-Renaissance Europe. In these histories, supposedly fixed categories – truth, sanity, criminality, gender – stood exposed, in the light of a bracing scepticism, as makeshift constructs erected by systems of power.

But while scepticism is in a sense the essence of campus – the place to question everything – comprehensive scepticism would constitute a declaration of 'ivory tower' indifference (and hence irrelevance) to all real-world issues. Academics might therefore wish to allow a foothold

for the real in their intellectual schemes. The Marxian art historian T. J. Clark invoked ideologies clashing in a war of 'representations or systems of signs' in his influential book about Manet and the Impressionists, *The Painting of Modern Life* (1984). For Clark, 'society is a battlefield of representations, on which the limits and coherence of any given set are constantly being fought for and regularly spoilt'. By this logic, reality would be the limits that each class-based representation came up against.

(d) *Representation as structure*. If vision is a matter of representing the world to the mind – an account of it that stems from Kepler's 1604 comparison of the eye to a camera obscura – then the knowledge the mind obtains constitutes 'mental representation'. In the 19th century, this idea was developed by the scientist Hermann von Helmholtz, who offered an account of all experience coming to consciousness in the form of 'signs'. It was also developed in logic by the American C. S. Peirce, with his 'semiotics' – an exhaustive classification of such signs – and by the German Gottlob Frege, working in the 1890s.

Frege discriminated in his account of linguistic representation, distinguishing reference – the relation of the sign to the thing – from sense – the relation of the sign to its context. Reference and sense are interdependent; when the sign and its context take the form of word and sentence, 'it is only in the context of a sentence that a word refers to anything'. This was a crucial distinction for thinkers in his wake: Wittgenstein in his earlier philosophy treated every reference as a 'picture' corresponding to reality, so that the sense of sentences that contained

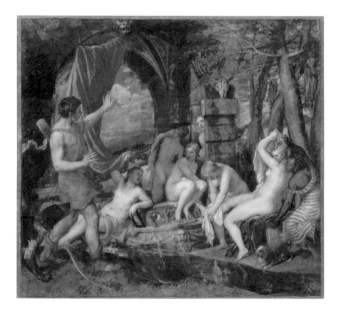

19. Titian, *Diana and Actaeon*, 1556–9. Oil on canvas.

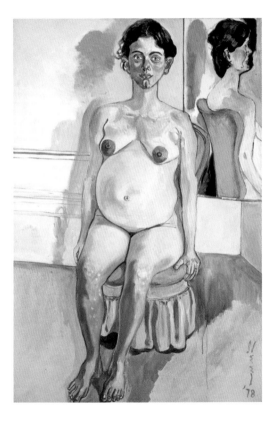

20. Alice Neel, *Margaret Evans Pregnant*, 1978.
Oil on canvas.

them was potentially like that of a map, or the index to a file of photographs.

With differing emphases, Frege and the earlier Wittgenstein were adopting what could be broadly termed a 'structural' way of thinking. That is to say, they were setting the subjects of their thought on two intersecting planes. One of them – in Frege's terminology, 'reference' – is equivalent visually to a moment of looking, a certain perception of a certain thing, what we might call an atom of experience. The other – 'sense' – is a structure that is not experienced in its own right, but which contains and determines experience.

This way of thinking can be seen not only when Marx talks about 'ideology' as a force that can invisibly shape experience into 'false consciousness', but equally in Freud's theories of an 'unconscious' that determines the shapes of immediate perception. Freud's work of the 1900s and 1910s ran alongside the linguistics of Ferdinand de Saussure. In these, as in Frege, it is not the relation of word to thing that determines meaning, but the relation of word to language as a total structure. Words do not get their meaning positively, by resemblance to things, but negatively, by difference from other words.

Structural thinking had analogues in the visual arts: the attempt to treat colour as a law that organizes perceptions or 'sensations', seen for instance in the paintings of Seurat; or, in the 1910s, Cubist collage, in which anything may represent anything by virtue of its place within a complex of excerpts. As the philosopher Jean-François Lyotard put it, painters from Cézanne onwards concerned

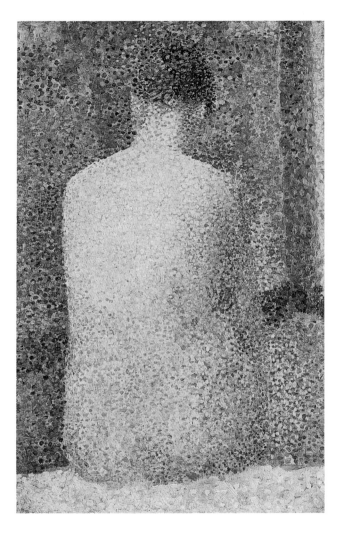

21. Georges Seurat, *Model, Back View*
(Poseuse de dos), 1887. Oil on board.

themselves 'to make seen what makes one see, and not what is visible'. The modernist era in art history – as defined by Clement Greenberg, an era in which painting purified its means – could be read this way also – as a progressive exploration of the structures that inform vision.

'Structuralisms' of this kind affected many fields of 20th-century endeavour. Insofar as this book proposes a matrix of terms for painting, it leans towards them, suggesting that feelings and perceptions are organized within certain abstract oppositions, and that experience can be mapped out as an expanse determined by their co-ordinates. The structuralists of postwar Paris, however – Claude Lévi-Strauss, for instance – characteristically went on from this to assert that the total structure had priority over the particular experience. Human experience was dependent on structures, whether you conceived of them on a social or a psychological level. They produced what Roland Barthes called 'the effect of the real', and this production was 'representation'.

Again there is some analogy between this way of thinking and contemporaneous approaches to painting. One of the recurrent images of mid-20th-century painting is what could be called the 'field' – the whole expanse of the picture treated as a totality within which objects, events or effects come into being. It is an image that cuts across the abstract / representational divide; it comes up in the fields of markings created by painters such as Paul Klee, Lyonel Feininger, Mark Tobey, Victor Vásárely or Maria Helena Vieira da Silva, in the 'colour-field' work of 1960s painters such as Morris Louis, or in the observational exploration

of the 'visual field'. In all of these, as in Barthes's phrase, reality is an emergent effect.

Have painters traditionally taken their cues from academic theorists, or has it been vice versa? For the most part, neither is true. Cultural history may reveal premises and methods loosely held in common, but it rarely has direct influences to trace. If many painters in the later 20th century turned away from the 'high art' values of abstraction, it is unlikely that many read the later philosophy of Wittgenstein. Nonetheless, there is some illumination in the comparison. Wittgenstein's later work sought to escape from his earlier philosophy, and from the whole split framework within which representation had been conceived in the earlier 20th century.

'A picture held us captive', he wrote, characterizing the linguistic bind he was seeking to escape – the picture being one of those window-like affairs dreamt up by Giotto and favoured by Alberti. This picture had captivated the earlier Wittgenstein and his generation because, taken as a model of reference, it seemed to open out the possibility of viewing the thing by itself and for itself – even while that view hung framed in the museum-like context supplied by 'sense'. As it was actually used, however, spoken and written language – claimed the later Wittgenstein – was not anything like a museum: it was more like an outdoor, loosely regulated, constantly shifting game between individuals. There were no atoms of experience, he claimed, no isolated moments of pure primary perception in which we could simply gaze at a

22. Maria Helena Vieira da Silva, *The Corridor (La Chambre Grise)*, 1950. Oil on canvas.

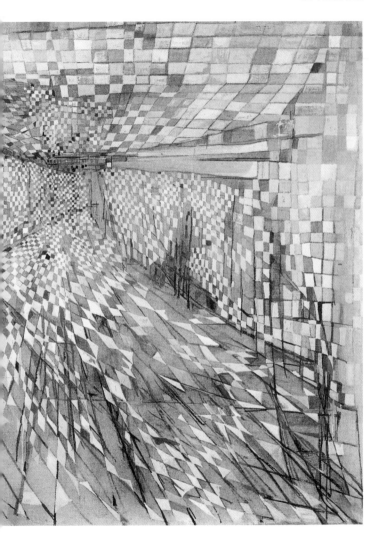

picture of the thing itself. Pictures, whether verbal or visual, were always seen 'as' something, always being described even in the process of perception.

This later teaching of Wittgenstein's, which began to be published after his death in 1951, left off approaching representation as a fixed interplay of pure reference with pure structure, focusing instead on utterances made in interpersonal dialogue. Meanwhile New York artists of the 1950s and 1960s, starting with Rauschenberg, dismissed the pure 'optical' experience of painting on which Greenberg insisted, putting together exhibits that embraced the street beyond the gallery doors in all its factuality, materiality and temporality. Impulses of this sort would resonate ever more widely through later 20th-century art.

While structuralism spread from Paris into anglophone campuses during the 1960s, its whole approach was being undermined, from angles other than Wittgenstein's, by further French theorists. Jacques Lacan's interpretations of Freud gained a growing audience at this time, describing human psychology as not only a system of differences but a continuity lacking any centre, with the watchful ego bedded down amidst the symbolic structures within which it was seen as emerging. A decentering strategy was also pursued by Jacques Derrida in *Of Grammatology*, a book published in 1967 and influential through the following three decades. Derrida's account of writing started where the account of painting in 'Expression' leaves off: denying the possibility of complete communication. I write, and you read, *now*;

but the sense of that word divides rather than unites us. All writing, he claimed, divides sense in this way, so that meaning is always already one step down the line; it resides nowhere, in a full experience of full presence, but is always deferred. It was disseminated across a structure that therefore had no kind of substance; therefore 'there is no representation of representation'.

Derrida fashioned statements that drew attention, with great sophistication, to their own inadequacy and inescapable incompleteness. In the later 20th century such statements could be encountered in visual art as well as in theory. Notably, Gerhard Richter talked of his photopainting as a conscious obstruction of communication:

> Life communicates itself to us through convention
> and through the games and laws of society.
> Photographs are ephemeral images of this
> communication – as are the pictures that I paint
> from photographs. Being painted, they no longer
> tell of a specific situation, and the representation
> becomes absurd....A picture presents itself as
> the Unmanageable, the Illogical, the Meaningless.
> It demonstrates the endless multiplicity of aspects:
> it takes away our certainty, because it deprives
> a thing of its meaning and its name.

Richter transcribed photographs with one hand, but with the other (as it were) he swiped and smeared abstractly and seemingly argumentatively – as if to assert that both tactics were equivalent in their communicative

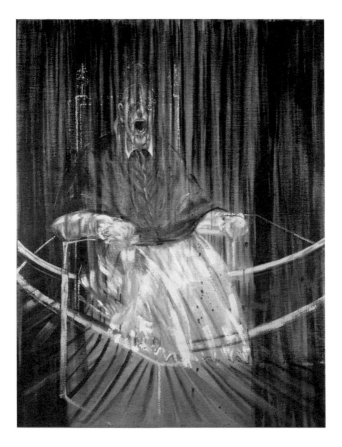

23. Francis Bacon, *Study after Velázquez's Portrait of Pope Innocent X*, 1953. Oil on canvas.

insufficiency. They failed to deliver, he said, what one might hope for from high art: 'I see myself as the heir to an enormous, great, rich culture of painting, and of art in general, which we have lost, but which nevertheless makes requirements of us.' A comparable note of historical pathos was struck by Francis Bacon lamenting that it was no longer possible to paint like Velázquez:

> You see, all art has now become completely a game
> by which man distracts himself; and you may say
> that it has always been like that, but now it's entirely
> a game. And I think that that is the way things have
> changed, and what is fascinating now is that it's going
> to become much more difficult for the artist, because
> he must really deepen the game to be any good at all.

But if the outlook seemed overcast to these prominent painters of the later 20th century, the prospects for those working in humanities departments seemed bright. For them, to invoke 'theory' was to salute a range of Paris-based authorities, both structuralist and 'post-structuralist' (i.e. sympathetic to Derridean deconstruction), including Lacan on the formation of 'subjectivity' or selfhood and Julia Kristeva on its fluidity; Foucault on the way that power informed the 'representations' of knowledge and social control; Luce Irigaray on representations of gender; and many sources besides. To talk of 'intertextuality' – a coinage of Kristeva's – was to celebrate and urge on this academic proliferation. A characteristic prospectus for a 'theory' course stated that:

> The unit will...consider those theories, principally
> of the late nineteenth and twentieth centuries, which
> undermine and critique the idea of representation,
> and which instead emphasise representation as the
> production and interpretation of 'knowledge' of
> a reality which cannot, in knowable form, pre-exist
> its representation.

The idea of representation, given the tortuous phrasing I have quoted, could be restated as a kind of myth, if we take 'myth' to mean a widely shared story about origins, as to the worth of which we suspend judgment. As I see it, the myth falls into two parts:

Representation is (or rather, was) an invisible spatial array – a configuration, a matrix, an abstract geometry – within which experience takes place. Within it, subjects like 'you' and 'me' and objects like 'this' and 'that' come into being: they exist purely as differences, as effects of spacing, within this total array.

But – representation itself does not exist. It is an idea, like God, invented to give things a backup promise of fixity, meaning and presence that they cannot deliver. If meanings shift, this suggests that there is a space within which they can shift. But to define this space is to fall into error: there is no all-encompassing geometry, there is only the local emergence of difference.

The appeal of this myth was that it could be used to deny substance both to the particular and to the abstract. As such it seemed to promise intellectual liberation, not only from the particular – as most philosophies do – but

from the intellectual tyrannies most philosophies set up in its place. Spreading in the 1980s to anglophone art studies, the approach was adopted and adapted by writers such as Norman Bryson and Rosalind Krauss.

At the same time, this eager adoption of 'theory' in the humanities pointed to a type of insecurity. What legitimated the study of culture, of human meanings and expressive actions? In order to maintain its intellectual status, did such study need to bind that live material within quasi-scientific neutral geometries? Or might it somehow fuse objectivity with subjectivity, overriding existing intellectual boundaries? Some exponents of 'theory' seemed to want to do this: some academics from the other side of campus hit back, notably the mathematician Alan Sokal who in 1995 damaged his opponents' credibility by getting them to publish a deliberately nonsensical spoof-theoretical article. From that point onwards, theory-based approaches to the humanities have tended to fall back onto the defensive.

It is true that the humanities have sought other ways to latch onto scientific authority. Some have gone to fMRI scans that offer pictures of what happens in the brain when a viewer looks at a painting. Semir Zeki, a scientist who analysed the processes occurring in the cortex and speculated how these might relate to concepts of beauty, came up with the formulation that, 'Artists are in some sense neurologists.' Modernist artists, at least: Zeki was restating Lyotard's aperçu, mentioned earlier in this chapter, that these, with their focus on isolated colours and forms, were painting 'what makes

one see'. It remains an open question whether the new 'neuroaesthetics' can do anything other than re-express in physical terms experiences and insights already familiar to working artists.

But if art studies have arrived at an insecure relation to science, artists' studio practices have arrived at an insecure relation to art studies. The chief reason is that over the past half-century art education has been largely brought within standard university constraints, with would-be artists now expected to produce extended and rigorously referenced written work in order to gain qualifications. (There is also the consideration that curators – the people artists may need to answer to, to gain public attention – will be professionally versed in art studies and its subject jargon.) As a result the studio's doors have been thrown open to the systematic questioning and principled scepticism that inherently belong to campus.

This is an awkward cohabitation. We have two sorts of skill here: 'liberal arts' that make demands on speech faculties, and the skills of hand and eye required to make physical objects. Even if neurology tells us nothing else, it points out that these use different parts of the brain. The tempos are different too. Critical debate is characteristically quickfire, while the hands-on making of an object worth looking at is very likely to be a slow, day-in, day-out process. From the 1970s onwards, an increasingly frequent response to this mismatch has been for the decision-making graduate – the art executive – to outsource the manufacture of the work itself to fabricators.

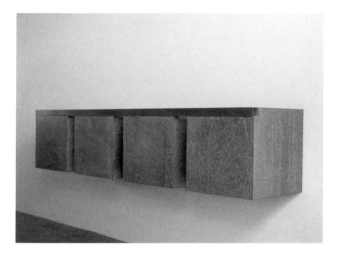

24. Donald Judd, *To Susan Buckwalter*, 1964.
Galvanized iron, aluminium and lacquer.

(The immediate prototype for this division of labour was the hands-off practice of Donald Judd, though it could be traced back to the Constructivist László Moholy-Nagy painting by telephone in 1922, in other words sending instructions for the colouring of panels down the line to a sign factory.) Concurrent with this tendency, the wordsmiths of art started to reach for an old familiar trope: 'the death of painting'.

The death of painting has been several times announced. 'I reduced painting to its logical conclusion and exhibited three canvases: red, blue and yellow. I affirmed: it's all over.' That was Rodchenko's funeral for the art in 1921. Walter Benjamin, writing in 1936, effectively agreed: painting had no ongoing role in a history now driven by dynamic mass politics.

Talk of the death of painting is also echoed in the pessimism that has coloured many painters' imaginations. Francis Bacon, believing that God was dead and that, therefore, one could no longer describe human beings with the religious conviction that Velázquez once possessed, spoke as if this forced painting into a corner: 'now it's entirely a game'. Richter, too, invoked a history of decline in speaking of a lost 'rich culture of painting, and of art in general'. Both, it might be said, reflected a lugubrious take on current historical conditions that was widespread in later-20th-century cultural circles. At the end of the modernist venture in art and of the horrors modern times had witnessed, a late-evening stormlight shone on culture. Soon it would be sundown, and then what use would there be for the old high-cultural forms?

Yet it might be added that myths of loss often serve as imaginative catalysts, helping painters to make something constructive out of their anxieties about overbearing predecessors. Surely Velázquez himself was aware of being a latecomer, challenged by the masterpieces that Titian had painted during the previous century for the Spanish royal collection.

But the death verdicts for painting that circulated from the 1980s onwards were not nostalgic in complexion. They were first pronounced in New York, by academic critics such as Douglas Crimp (in his essay 'The End of Painting', 1981), but it might well be said that some painters in that city had already brought these sentences down upon their own practice. During the 1960s, while Greenberg urged artists to concentrate on the means of their art, Ad Reinhardt, a contrarian quite as argumentative as he, outflanked his call for purity by exhibiting *Ultimate Paintings* consisting of subtly differentiated squares of black. A Reinhardt canvas was meant to be unsurpassable in its negations:

> a pure, abstract, non-objective, timeless, spaceless,
> changeless, relationless, disinterested painting –
> an object that is self-conscious (no unconsciousness),
> ideal, transcendent, aware of no thing but art
> (absolutely no anti-art).

Supposing you took this seriously and that you still wanted to make something to look at, you would surely need to step away from a medium that had, by Reinhardt's

choice of epithet, arrived at its final destination. (When Rothko died by suicide in 1970, a common reaction was that he too with the ever narrower terms of his 'signature style' had reached a veritable dead end.)

You might from this point move on as an artist by adopting wholesale the Minimalist aesthetic half-implied by Reinhardt's rhetoric. You might make a physical object which still involved paint, but if so, it would lack the duplicity that any figure-ground, colour-against-colour relationship sets up. You would thereby escape the strictures of Donald Judd, who disapproved of the invention of visual fictions as a matter of philosophical principle. And if you also eschewed manual brushwork, you would avoid the scorn that Judd's co-exhibitor Robert Morris expressed for 'tedious object production'. You would hardly have made anything like a painting, in the historical sense of the term.

Alternately, you might accept that 2D representations were inescapable, and that this inescapability – in a capitalist system where publicity images endlessly proliferated – was itself a condition that artists needed to address. This much was accepted by the painters who created 1960s Pop Art, but in the wake of Minimalist critiques, it was no longer obvious to the upcoming artists of the following decade that paint was a fit medium to tackle the issue of what 'pictures' now involved. You might more incisively use photography to criticize photography, or the new medium of video to transact between source and reproduction. If American artists of this 'Pictures generation' – Cindy Sherman, Richard Prince, Sherrie

Levine, et al. – dealt in painting at all, it was in order to contextualize and ironize that particular cultural practice, generally through 'appropriation'. In other words, through image quotation. Levine gave handsome expression to its rationale in a 1981 text:

> The world is filled to suffocating. Man has placed
> his token on every stone. Every word, every image
> is leased and mortgaged. We know that a picture
> is but a space in which a variety of images, none of
> them original, blend and clash. A picture is a tissue
> of quotations drawn from the innumerable centres
> of culture. Similar to those eternal copyists Bouvard
> and Pécuchet [in Flaubert's novel of that name],
> we indicate the profound ridiculousness that is
> precisely the truth of painting.

Levine's sceptical cancellation of originality was paralleled in the writings of Jean Baudrillard, whose accounts of 'hyperreality' – a state of affairs in which no prior reality exists and all is always copy (or 'simulacrum') – captured, for many in the 1980s and 1990s, the texture of the postmodern world. Wised up in this way, 'Pictures' artists adopted the anti-expressionist (or 'anti-humanist') mindset previously discussed in this book. What mattered at the turn of the 1980s to the academically articulate artist was to battle against the emotional self-indulgence displayed by 'Neo-expressionists' such as Sandro Chia or Julian Schnabel. All the more so, because of the latters' success in marketing florid impastos and deliberately

goofy, 'bad' brushwork as demonstrations of a supposed fresh resurgence of painting. For the New York theorist Craig Owens, Neo-expressionism constituted 'a desperate, often hysterical attempt to recover some sense of mastery', indicative of last-ditch anxieties about a loss 'of virility, masculinity, potency'.

Owens staked out an opposition to any pretended revival of painting on principle, expressing his solidarity with feminism as a gay activist. The contention was that a tradition headed by artists like Titian, Picasso and Pollock bore an inherently aggressive patriarchal demeanour. As Berger had already argued, this medium had a historical complicity not only with capitalism but with the objectification of women, and this complicity could best be addressed by stepping outside it.

If in the studio you might do so by appropriation, on campus you might do so by appealing to the concept of 'the gaze'. The term, adapted in 1975 by the film critic Laura Mulvey from Lacan's *le regard*, indicated a field of visual tension within which subjects and objects separated and polarized. Equipped with this concept, you could approach the watcher's relations with the watched (whether these were male with female, ruler with ruled or audience with artwork) not simply in terms of opposition, but rather as a psychological ecosystem. It was unlikely that you would describe that ecology neutrally, however. If you synthesized this idea with Foucault's schemata that described the history of knowledge as a history of power relations, you would arrive at a 'gaze' that had operated as a macho, malevolent dictator,

locking genders, classes and perhaps ethnicities into a long-term historical pathology of which painting itself was merely a symptom.

The 'death of painting' theme, then, combined lofty intellectual overviews with an everyday doubt that had beset many an artist during the 20th century and that continued through its final, 'postmodern', decades: weren't there better ways to make things nowadays, rather than sticking with old-fashioned oil paint and canvas? The theme also found its place in a culture in which left-wing projects of social transformation were being pushed onto the defensive. Their best hopes now of realization lay not in mass action, but in cultural guerrilla warfare conducted from the sanctuary of the campus. And because of the closer mesh between humanities education and the politics of exhibiting, the rearguard fight was also being conducted from those associated free zones, the 'white cubes' – the galleries of contemporary art.

Reflecting on the context underlying the 'death of painting' in a 2003 colloquium, Lane Relyea sketched the view as it appeared from his chair on an American campus:

> Sometime between the '60s and the '80s, discourse
> replaced painting as the dominant medium in
> the art world....The pervasive sense that artworks
> are a subspecies of discourse, that they depend for
> their legibility, their legitimacy, on discourse – that
> they are most fully revealed in books and magazines,
> in dual-slide-projector lectures and artists' talks,
> in informed discussions among art-world

> professionals – did much to erode conviction
> in the single static image....It's in this context
> that perhaps it makes some sense to say that
> paintings 'look better in reproduction'.

The analysis is provocative and apt. But by 2003, when Relyea was speaking, it had become clear that easel painting had failed simply to die the death, in the way that miniature painting once had (an art which, as it happens, was itself experiencing a startling revival, among artists associated with the National College of Arts in Lahore). Some of the reasons why are mundane. For all the steel-and-glass and flow-through space of contemporary exhibition venues, most of them still end up with some interior walls, and if these walls are to be punctuated with exhibits to look at, it is very, very hard (though not necessarily impossible) to find a medium that delivers anything to match the visceral impact and complex emotional and intellectual engagement provided by a strong painting – however much compromised and complicit historical baggage that artefact may inject into the pristine architecture, or perhaps exactly because it is prone to carry such a turbid weight.

Moreover a supply of at least *sufficiently* strong painting was on offer throughout the 'death of painting' era, thanks to the residual resilience of a product tradition supported by large investments of expertise, equipment and designated workspaces (i.e. studios). For instances I could appeal to my own tastes (pointing directions as various as Anselm Kiefer, Jean-Michel Basquiat,

Julie Mehretu, or Tomma Abts: though there could be so many others) but the bottom line is the question of whether artists in other media have produced wall hangings of unarguably richer interest than these, or than whatever your own preferred roll call may be. Many of us might want to argue that our chosen survivor painters from this era came through exactly because the critiques of the medium put them to the test and obliged them to think harder. Painting has had to work for a niche in the limelight: it can no longer assume, as it could until the 1960s, that it tops the hierarchy of the arts. And that is proper; good riddance to hierarchies! But the pattern that emerges would satisfy any conservative historian: painting's survival as a case of modulated continuity.

In asking what medium generates more 'interest', I'm aware of touching not only on the history, but on the rights and wrongs of the now more or less exhausted debate. 'A work needs only to be interesting': so said the fact-loving Donald Judd, proposing that a 'specific object', a simple, physical 3D thing, could give out more to the viewer than a flat, multicoloured, illusionary juggle of optical stimuli. Plato the idealist would come to the same conclusion, if for opposite reasons: at least the simple object would bring the viewer nearer to the God-given original form. In their own terms, there can be no arguing with either. But if there is a commentator who is able at once to oversee and to overturn both, it is Friedrich Nietzsche:

25. Tomma Abts, *Oke*, 2013. Acrylic and oil on canvas.

If we had not approved of the arts and invented this
kind of cult of the untrue, the insight into universal
untruth and mendaciousness now provided to
us by science – the insight into illusion and error
as a condition of knowing and feeling existence –
could in no way be endured.

I'd add three footnotes to that sardonic oracular pro-
nouncement. Firstly, if the love of painting is a kind of
cult, cults take hold because they offer sweetness, as
well as relief from anxiety: but to say that sweetness –
pleasure – is itself an illusion, would be a category mis-
take. Secondly, that visual arts in general are caught up
in this: it is not only painting that leans on the comforting
appeal of myth, expressionism and optical pizzazz, but
most (admittedly not all) of its alternatives. Witness, for
instance, the popular work of Damien Hirst, presenting
traditional metaphors dressed up in post-Minimalist
décor. Thirdly, that this isn't at heart a cult of the untrue.
Myth is basically inescapable. We all have to reach for
some overarching story-about-conditions that we might
be able to trust. Painting can be a way of so reaching.

26. Julie Mehretu, *Black City*, 2007.
Ink and acrylic on canvas.

BIBLIOGRAPHY

Original and Image

The Second Commandment, Exodus 20, verse 4

The Wisdom of Solomon (in the Apocrypha, or non-canonical books of the Old Testament), chapter 13, verses 13–16, and chapter 15, verse 4

Aristotle, *Poetics*

David C. Freedberg, *The Power of Images* (University of Chicago Press, 1986), chapter 14

Ernst Gombrich, *Meditations on a Hobby Horse* (Phaidon, 1963)

Louis Marin, *Portrait of the King* (1981: trans. M. Houle, Macmillan, 1988)

Jaroslav Pelikan, *Imago Dei* (Yale University Press, 1990)

Plato, *The Republic*, Book X

Pliny, *Natural History*, book 35, section 43

Paintings and Painting (and Photographs)

Thomas Hobbes, *Leviathan* (1651), chapters 16 and 45

Craig Owens, 'Representation, Appropriation, Power', *Beyond Recognition* (University of California Press, 1987)

Plato, *Cratylus*

Pliny, *Natural History*, Book 35

Tsvetan Todorov, *Theories of the Symbol* (1977; translation Blackwell, 1982)

Expression

The Spiritual in Art: Abstract Painting 1890–1985 (exh. cat., Los Angeles County Museum of Art, 1986)

Charles Baudelaire, Salon of 1846, *Art in Theory 1815–1900*, ed. Charles Harrison, Paul Wood and Jason Gaiger (Wiley-Blackwell, 1998, 2001), p. 259

Anna Chave, *Mark Rothko: Subjects in Abstraction* (Yale University Press, 1991)

Morgan Falconer, *Painting beyond Pollock* (Phaidon, 2015)

John Gage, *Colour and Culture* (Thames & Hudson, 1995)

Vasily Kandinsky, *On the Spiritual in Art* (1913)

Martin Kemp, *The Science of Art* (Yale University Press, 1990)

Paul Klee, *On Modern Art* (1924)

Maurice Merleau-Ponty, 'Eye and Mind', *The Merleau-Ponty Aesthetics Reader* (Northwestern University Press, 1994, edited by Galen A. Johnson and Michael B. Smith)

Novalis fragment, epigraph to Joseph Leo Koerner, *Caspar David Friedrich and the Subject of Landscape* (Reaktion, 1994)

Jean Renoir, *Renoir* (Hachette, 1962), p. 77

Jean de Rotonchamp, *Gauguin* (1906)

John Ruskin, *The Elements of Drawing* (1857), Letter I, Exercise 1, note 1.

Vincent van Gogh: The Letters, ed. Nienke Bakker (Thames & Hudson, 2009), letters written 18 August and 16 October 1888

Representation

Roland Barthes, 'L'effet de réel', *Communications* 11 (1968), 84–89

John Berger, *Ways of Seeing* (Penguin, 1972)

P. Brunette and D. Wills (eds) *Deconstruction and the Visual Arts* (Cambridge University Press, 1994)

T. J. Clark, *The Painting of Modern Life* (Princeton University Press, 1985)

Friedrich Ludwig Gottlob Frege, *Sense and Reference* (1892)

Hermann von Helmholtz, 'On the Relation of Optics to Painting' (1881)

Sherrie Levine, 'Statement', 1982, *Art in Theory 1900–2000*, p. 1066

Jean-François Lyotard, *The Inhuman: Reflections on Time* (Stanford University Press, 1992)

Robert Morris, 1969, *Art in Theory 1900–2000,* ed. Charles Harrison and Paul Wood (Wiley-Blackwell, 2002), p. 868

Laura Mulvey, 'Visual Pleasure and Narrative Cinema', 1975, *Art in Theory 1900–2000*, p. 963.

Friedrich Nietzsche, *The Gay Science* (1882), section 107

Craig Owens, 'The Discourse of Others' (1983), *Beyond Recognition* (University of California Press, 1994)

Ad Reinhardt, *Art as Art: The Selected Writings of Ad Reinhardt* (University of California Press, 1992)

Lane Relyea, 2003 discussion hosted by *Artforum* magazine <www.artforum.com/inprint/issue=200304&id=4507> (accessed 16 January 2017)

Gerhard Richter, *The Daily Practice of Painting: Writings 1961–2007* (D.A.P., 2009)

Alexander Rodchenko, 'My Work with Mayakovsky' (1939)

David Sylvester, *Interviews with Francis Bacon* (Thames & Hudson, 1980)

Ludwig Wittgenstein, *Philosophical Investigations* (1953)

Semir Zeki, *Inner Visions* (Oxford University Press, 1999)

LIST OF ILLUSTRATIONS

Measurements are given height before width, cm followed by inches

1. A relief from the tomb of Ankhmahor, Saqqara, showing Egyptian sculptors working on two statues (detail), Sixth Dynasty, c. 2345–2181 BCE. Photo Werner Forman/Universal Images Group/Getty Images **2.** David Allan, *The Origin of Painting ('The Maid of Corinth')*, 1775. Oil on panel, 38.7 × 31 (15¼ × 12¼). National Galleries of Scotland, Edinburgh. Presented by Mrs Byres of Tonley 1875. NG 612 **3.** *The Vernicle*, 12th century. Tempera on wood, 77 × 71 (30⅜ × 28). Tretyakov Gallery, Moscow **4.** Hermenegildo Bustos, *Still Life with Fruits, Scorpion and Frog (Bodegón con Frutas, Alacrán y Rana)*, 1874. Oil on canvas, 43.3 × 35.3 (17⅛ × 14). Museo Nacional de Arte, Mexico City **5.** Giotto, *An illusionistic window* (detail), 1303–5. Fresco, 150 × 140 (59⅛ × 55⅛). Scrovegni Chapel, Padua **6.** George Stubbs, *Portrait of a Monkey*, 1774. Oil on panel, 70.5 × 60.3 (27¾ × 23¾). Private Collection. **7.** Attributed to Mao Song, *Monkey*, 13th century. Ink, colour and gold on silk, 46 × 37 (18⅛ × 14⅝). Tokyo National Museum. TA-297 **8.** Ottomar Anschütz, *Monkey*, c.1886. Albumen print, 20.2 × 14.7 (8 × 5¾). Rijksmuseum, Amsterdam. RP-F-00-3401 **9.** Workshop of Giovanni Battista Cima da Conegliano, *The Virgin and Child with Saint Andrew and Saint Peter* (unfinished), late 15th–early 16th century. Oil on panel, 47.7 × 39.7 (18¾ × 15⅝). National Gallery of Scotland, Edinburgh. Presented by Miss Margaret Peter Dove 1915. NG 1190 **10.** James Abbott McNeill Whistler, *Nocturne: Blue and Silver – Cremorne Lights*, 1872. Oil on canvas, 50.2 × 74.3 (19⅞ × 29⅜). Tate, London. N03420 **11.** Georgiana Houghton, *The Omnipresence of the Lord*, 31 October 1864. Watercolour and gouache on paper, 23 × 32 (9⅛ × 12⅝). Collection Victorian Spiritualists' Union, Melbourne **12.** Vasily Kandinsky, *Composition VI*, 1913. Oil on canvas, 195 × 300 (76 × 118⅛). The State Hermitage Museum, St Petersburg. ГЭ-9662 **13.** Pablo Picasso, *Guernica*, 1 May–4 June 1937. Oil on canvas, 349.3 × 776.6 (137⅝ × 305¾). Museo Nacional Centro de Arte Reina Sofía, Madrid. DE00050. © Succession Picasso/DACS, London 2024 **14.** Rudy Burckhardt, *Jackson Pollock Painting No. 32*, 1950. Burckhardt © ARS, NY and DACS, London 2024. Pollock © The Pollock-Krasner Foundation ARS, NY and DACS, London 2024 **15.** Robert Ryman, *Untitled*, 1965. Oil on linen, 28.4 × 28.2 (11¼ × 11⅛). The Museum of Modern Art, New York. Gift of Werner and Elaine Dannheisser. 201.1996. © Robert Ryman/DACS, London 2024

Be the first to know about our new releases, exclusive content and author events by visiting
thamesandhudson.com
thamesandhudsonusa.com
thamesandhudson.com.au

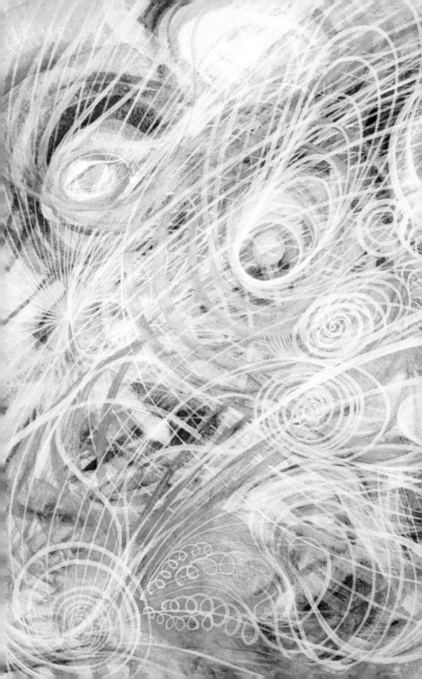